Swear Words

Adult Coloring Book

De-stress and Color Them!
60+ Designs

Copyright 2016

Rude Awakening

All Rights reserved. No part of this book may be reproduced or used in any way or form or by any means whether electronic or mechanical, this means that you cannot record or photocopy any material ideas or tips that are provided in this book.

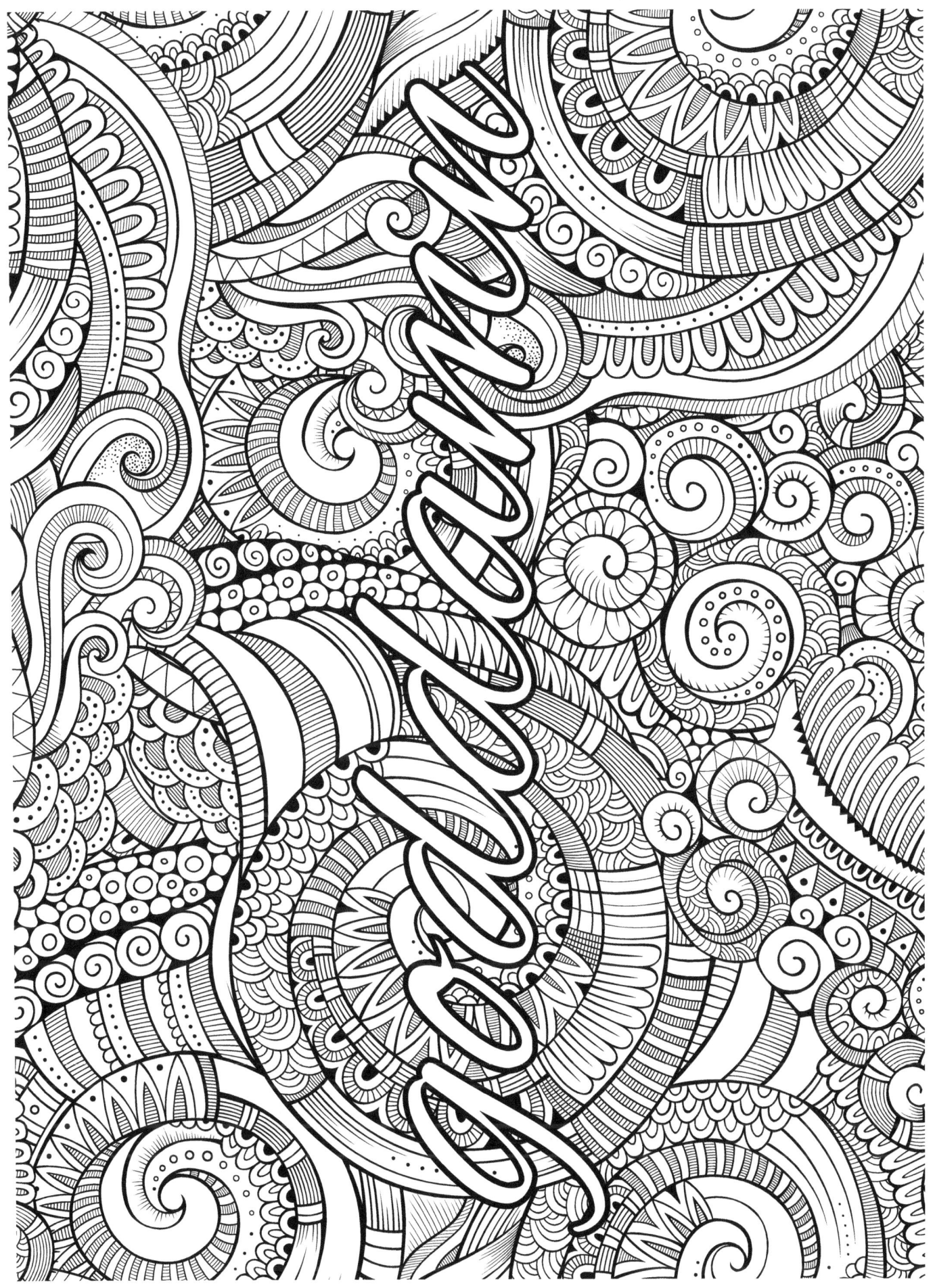

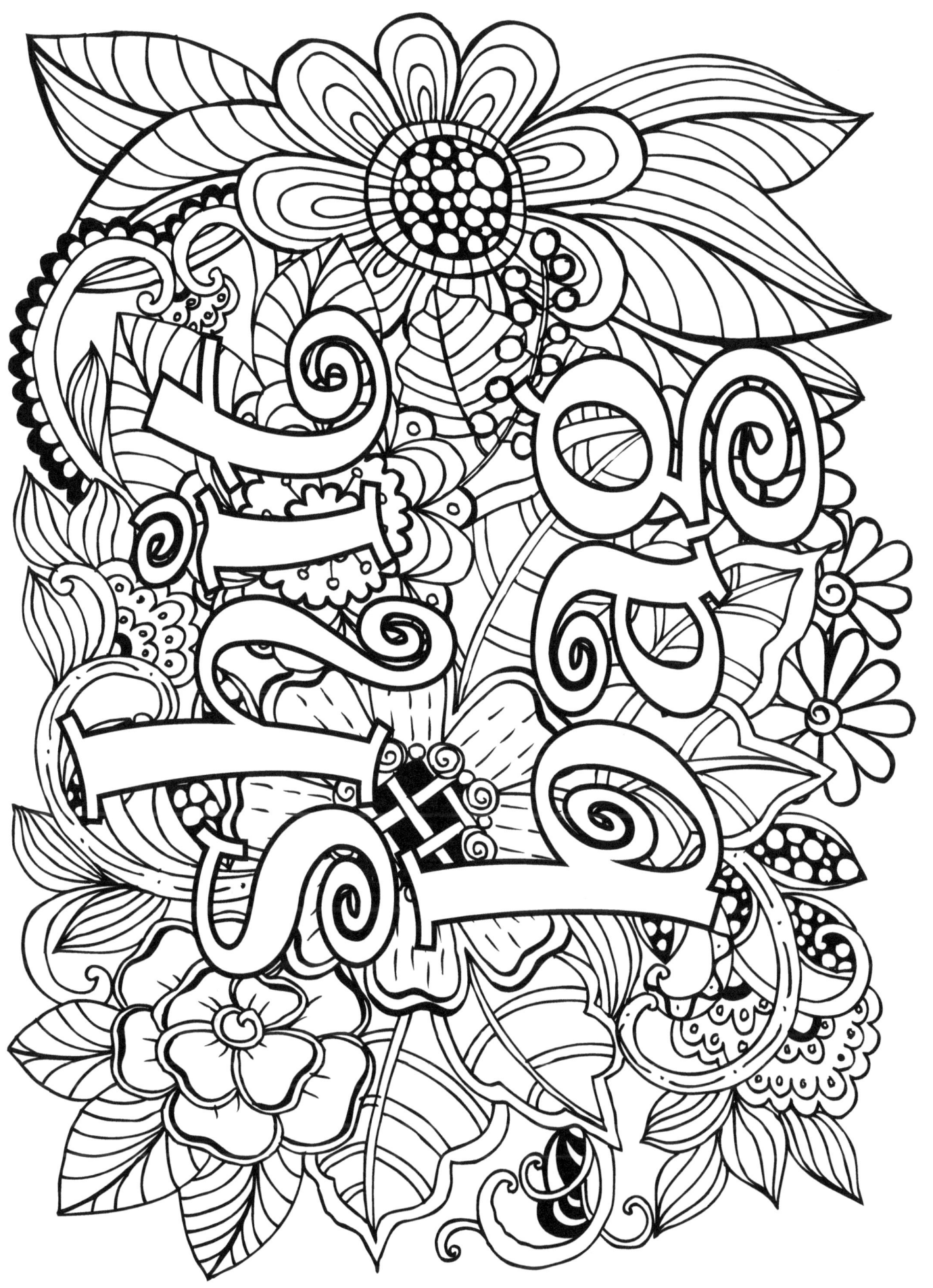

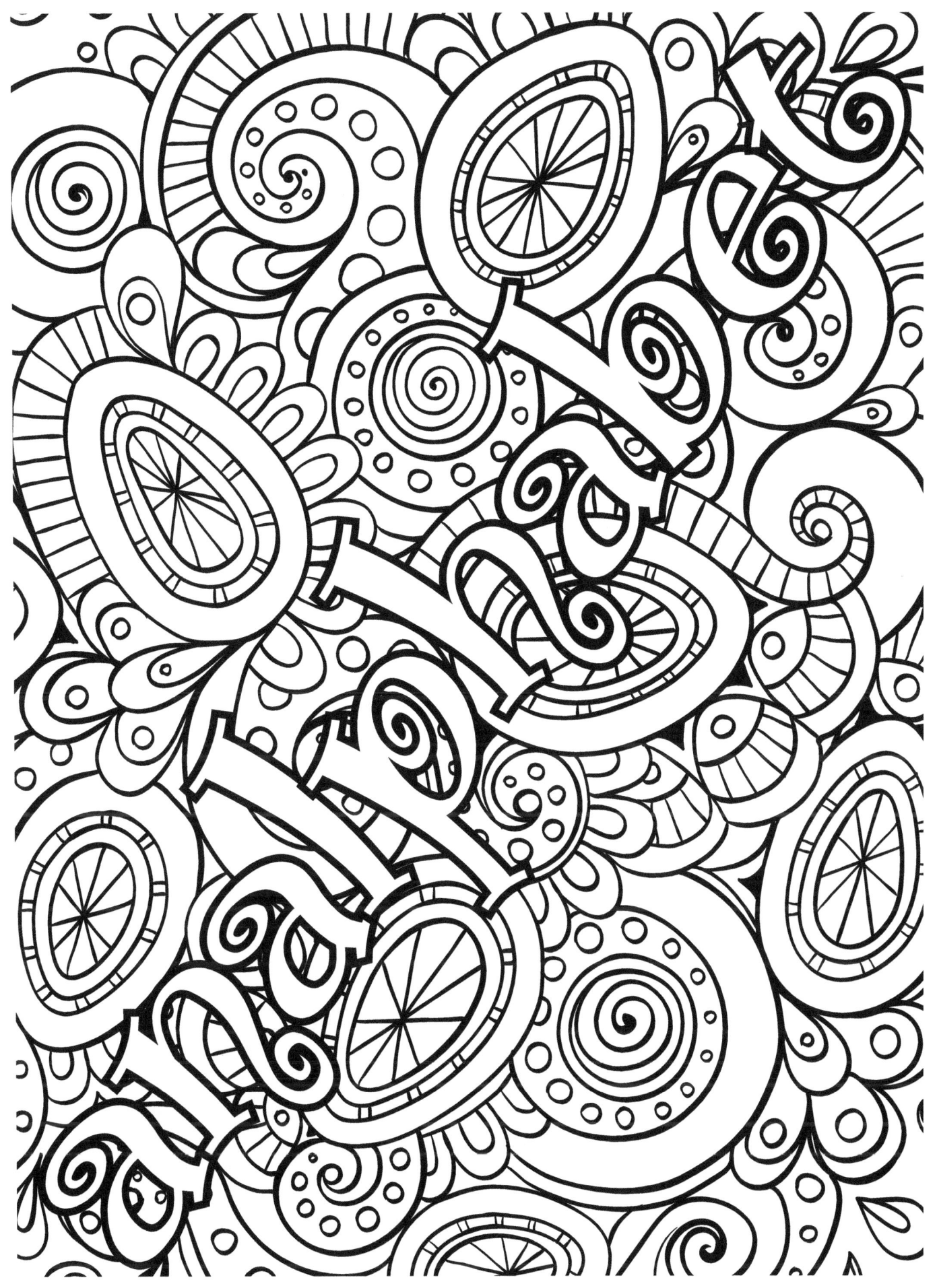

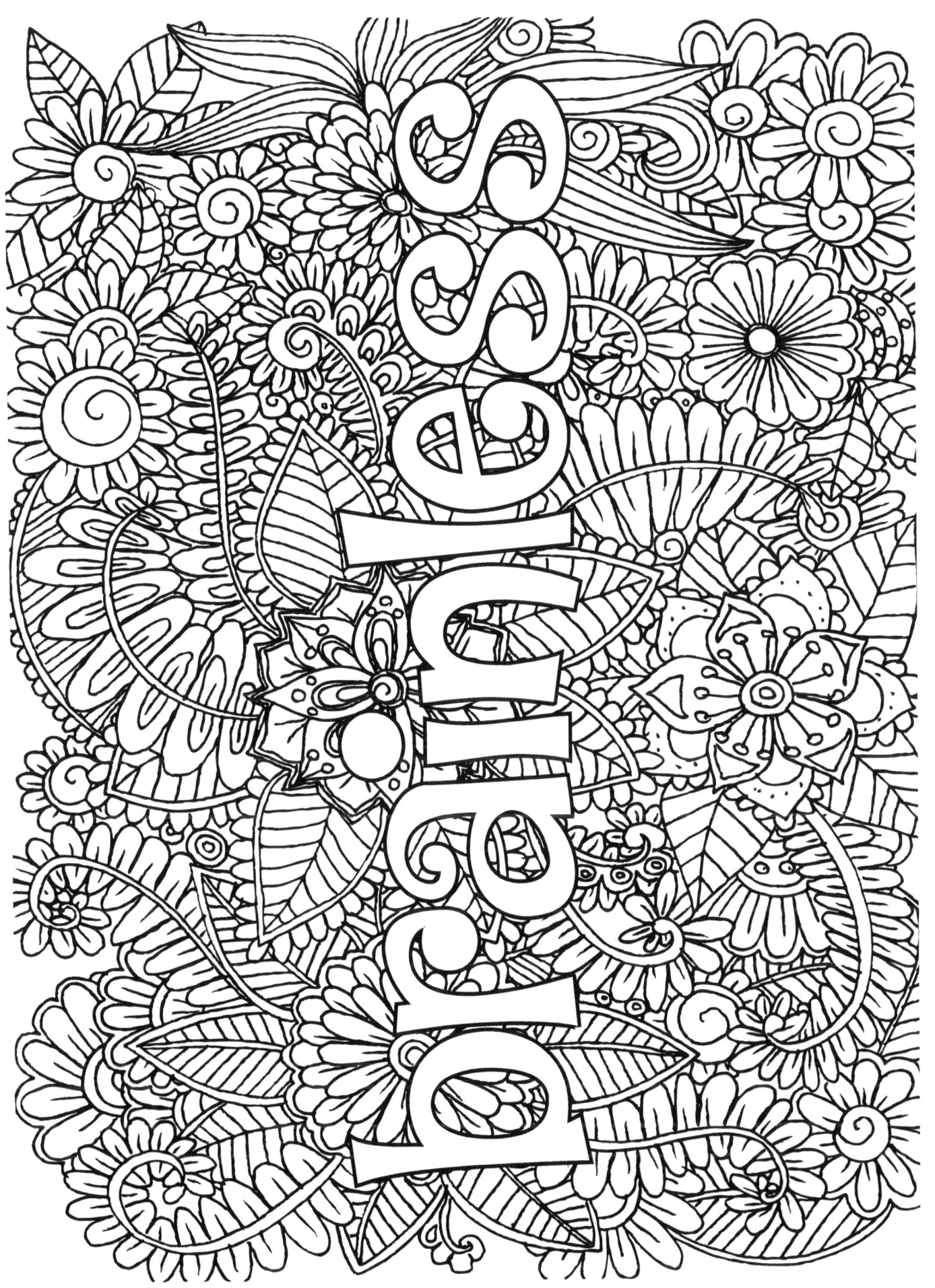

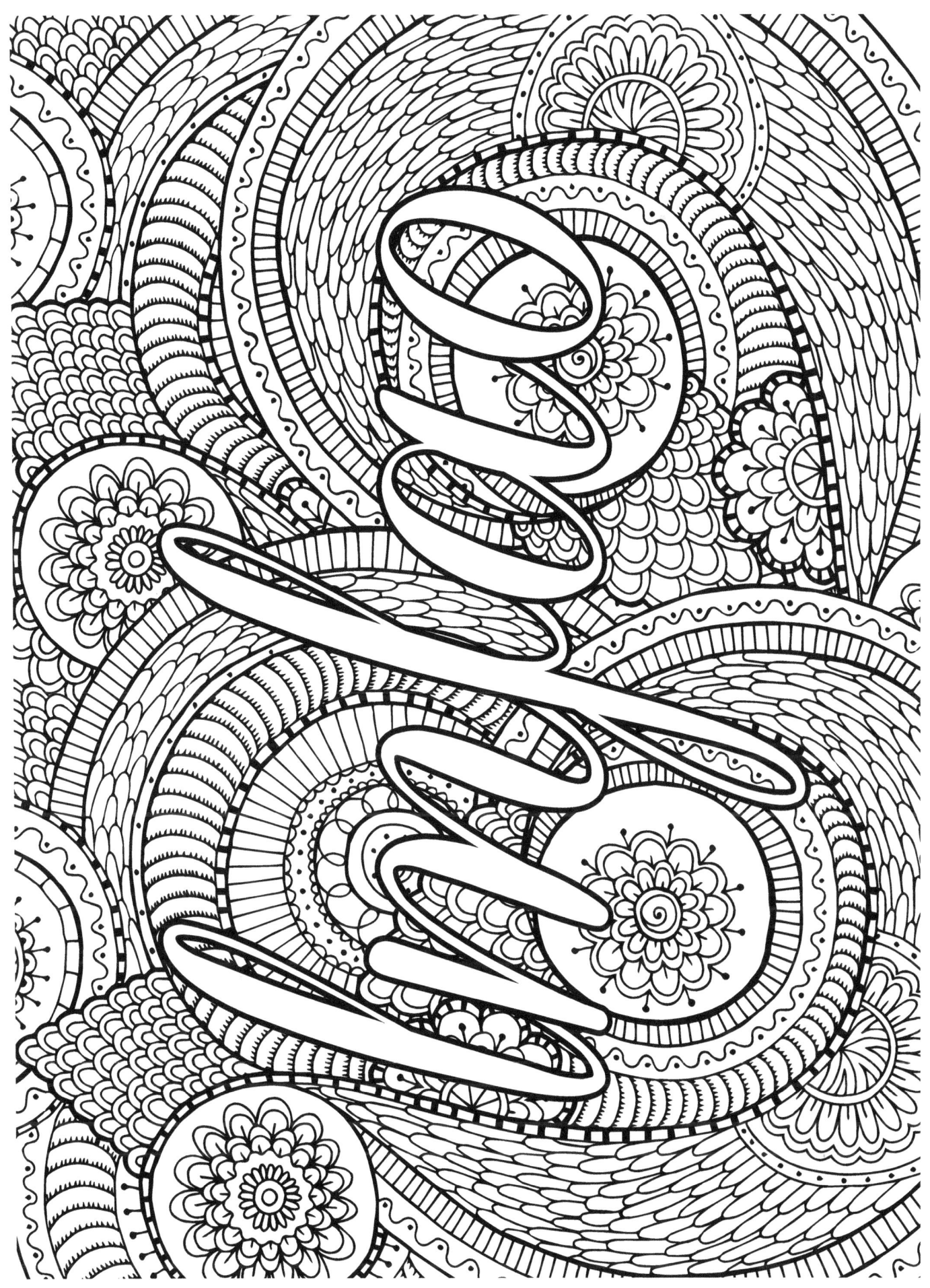

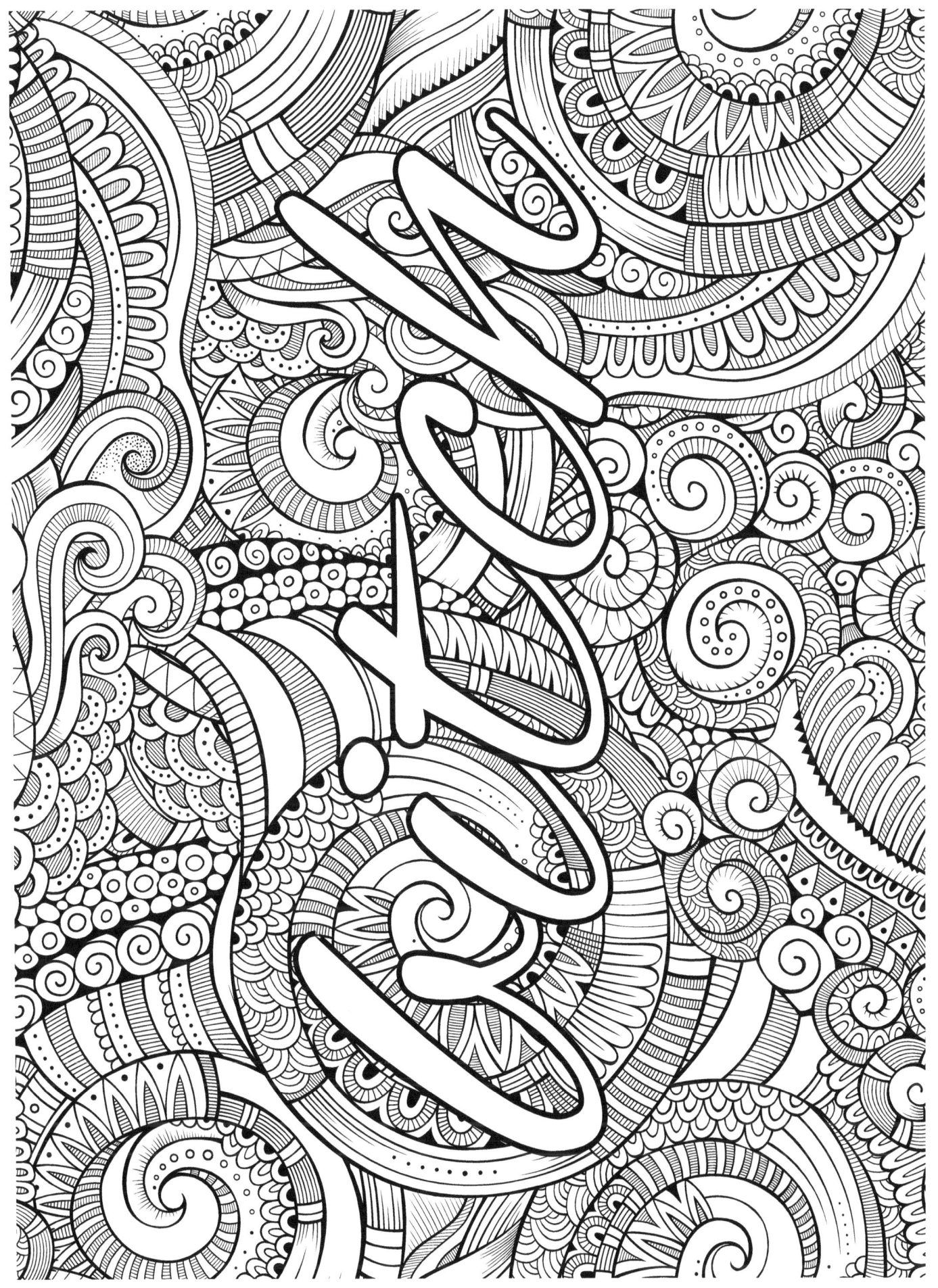

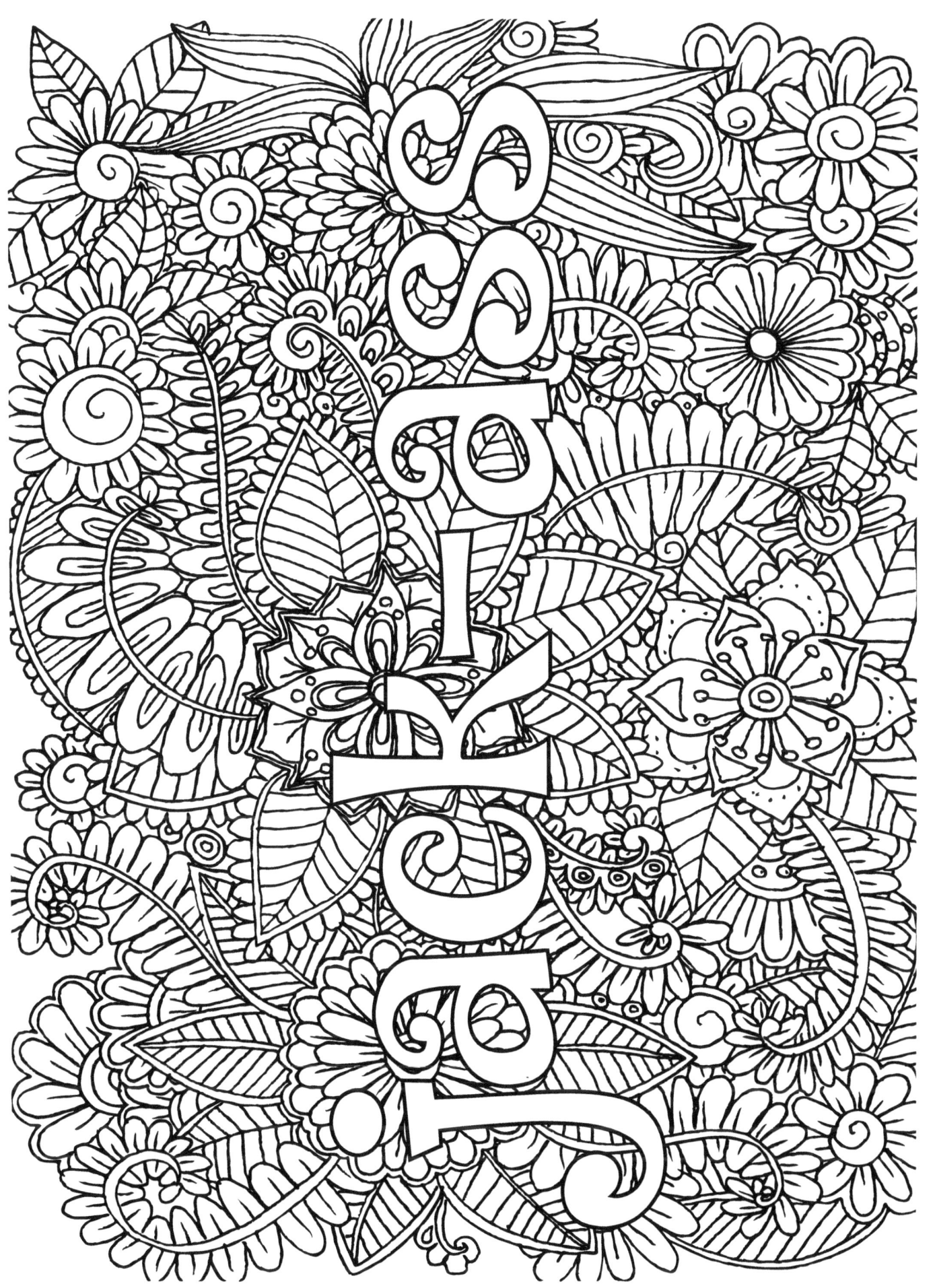

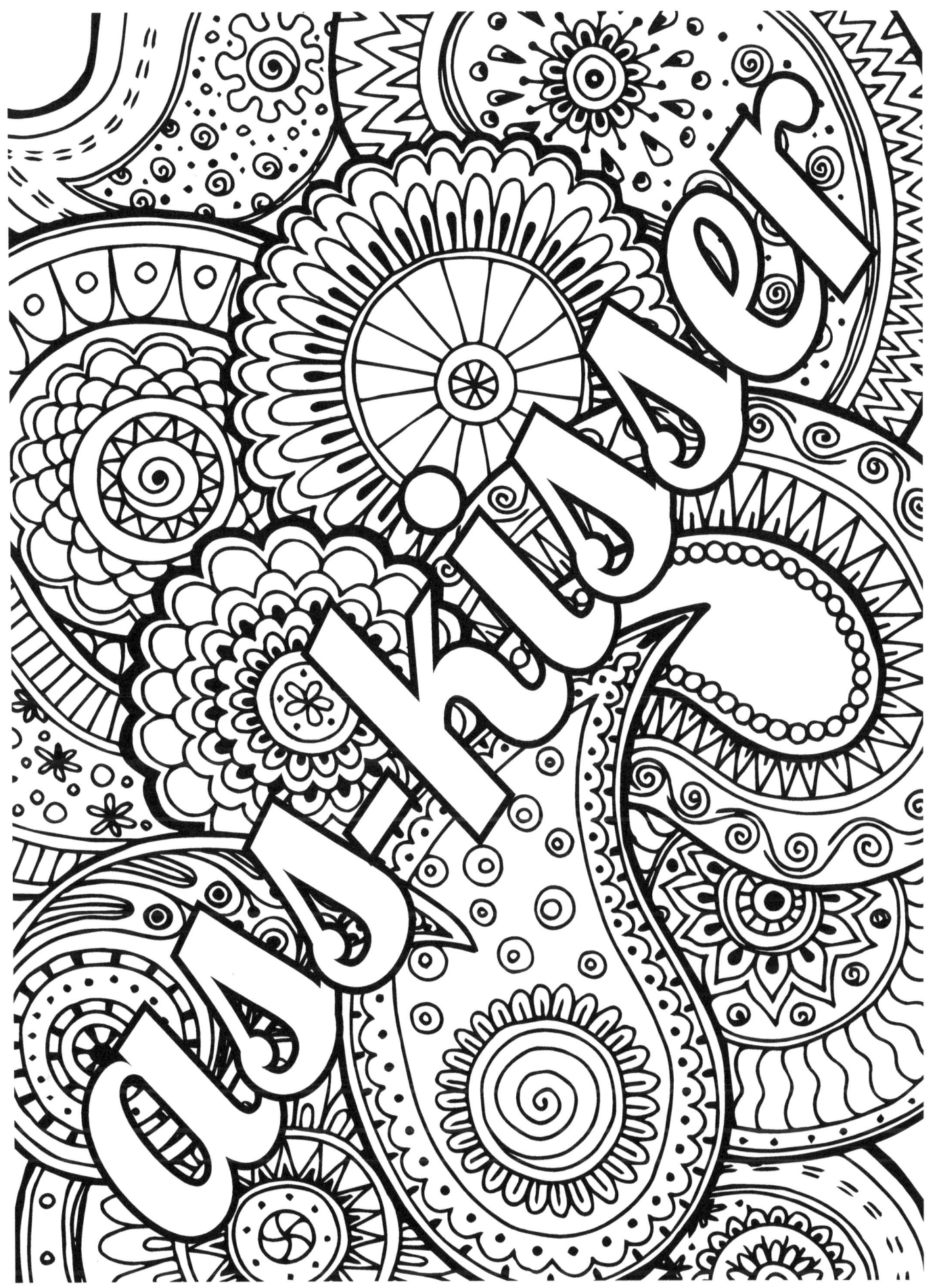

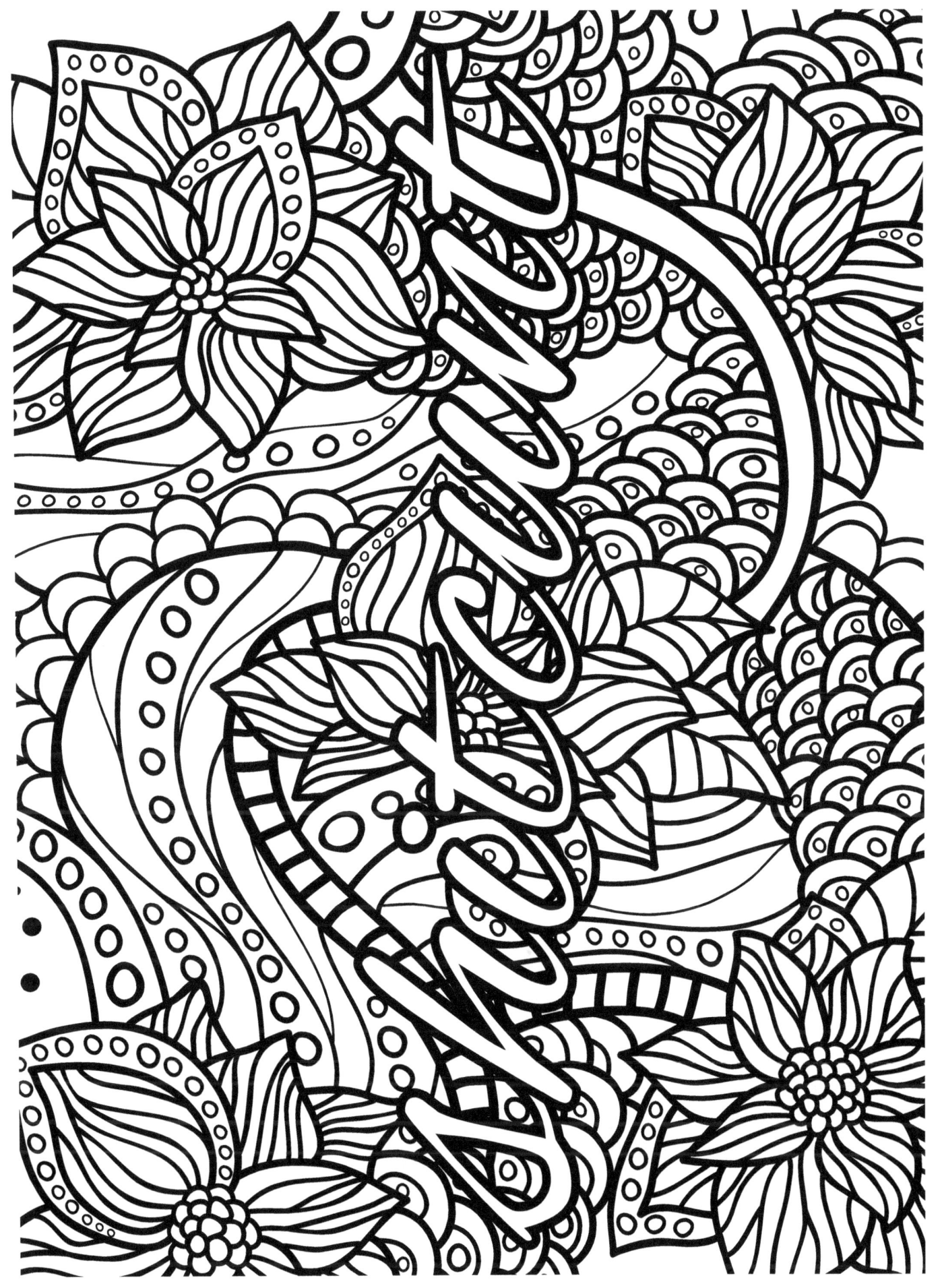

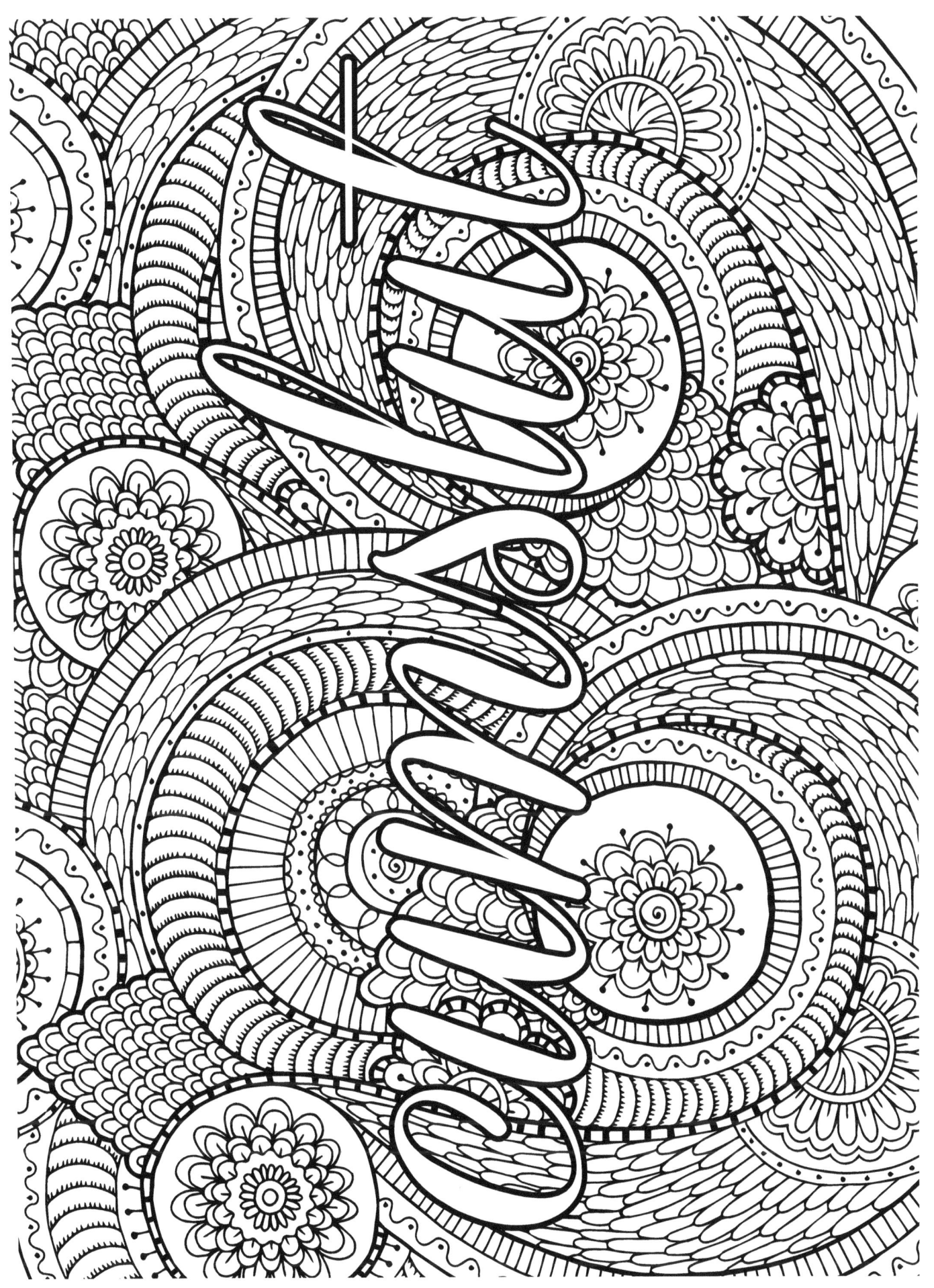

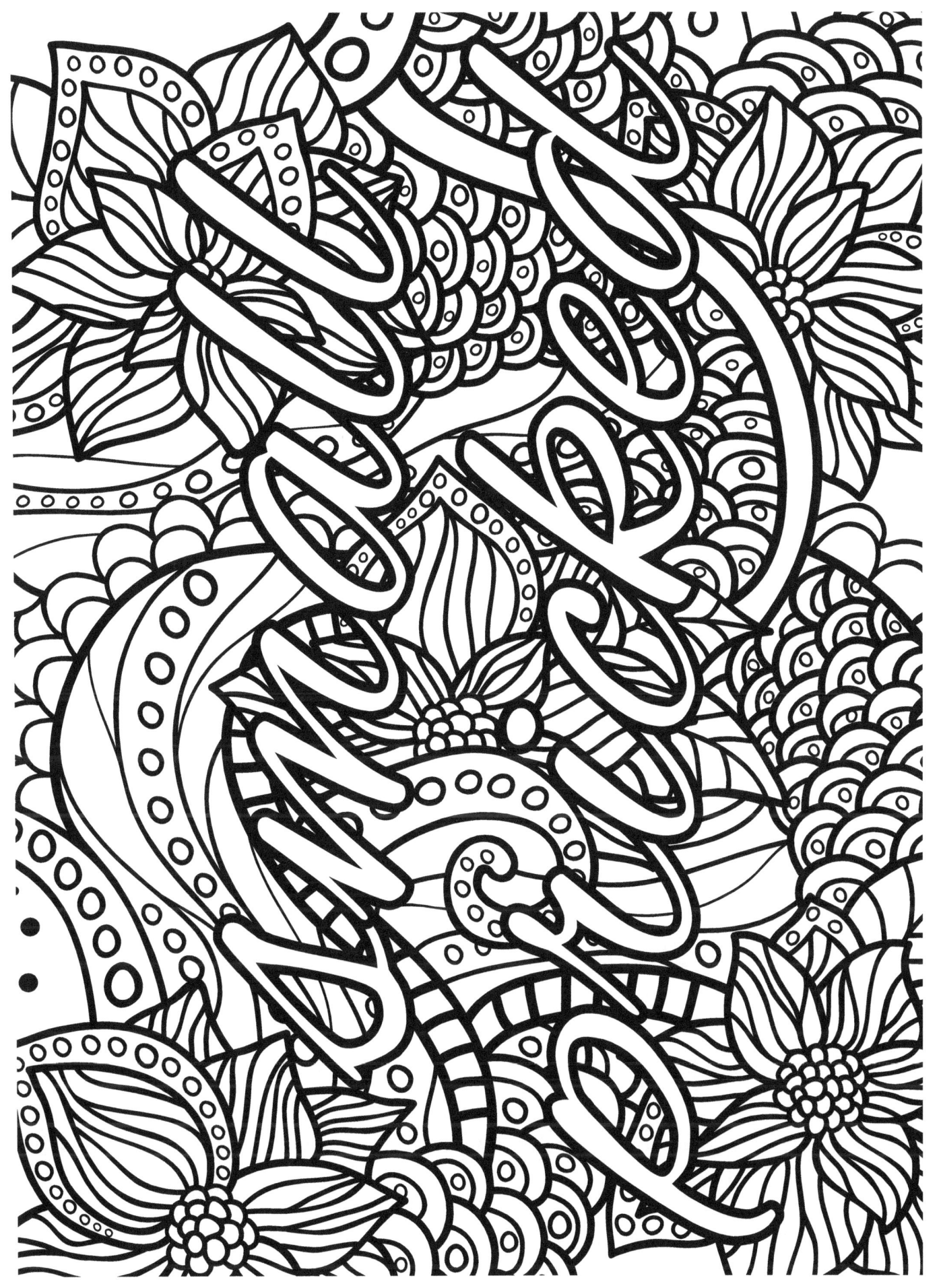

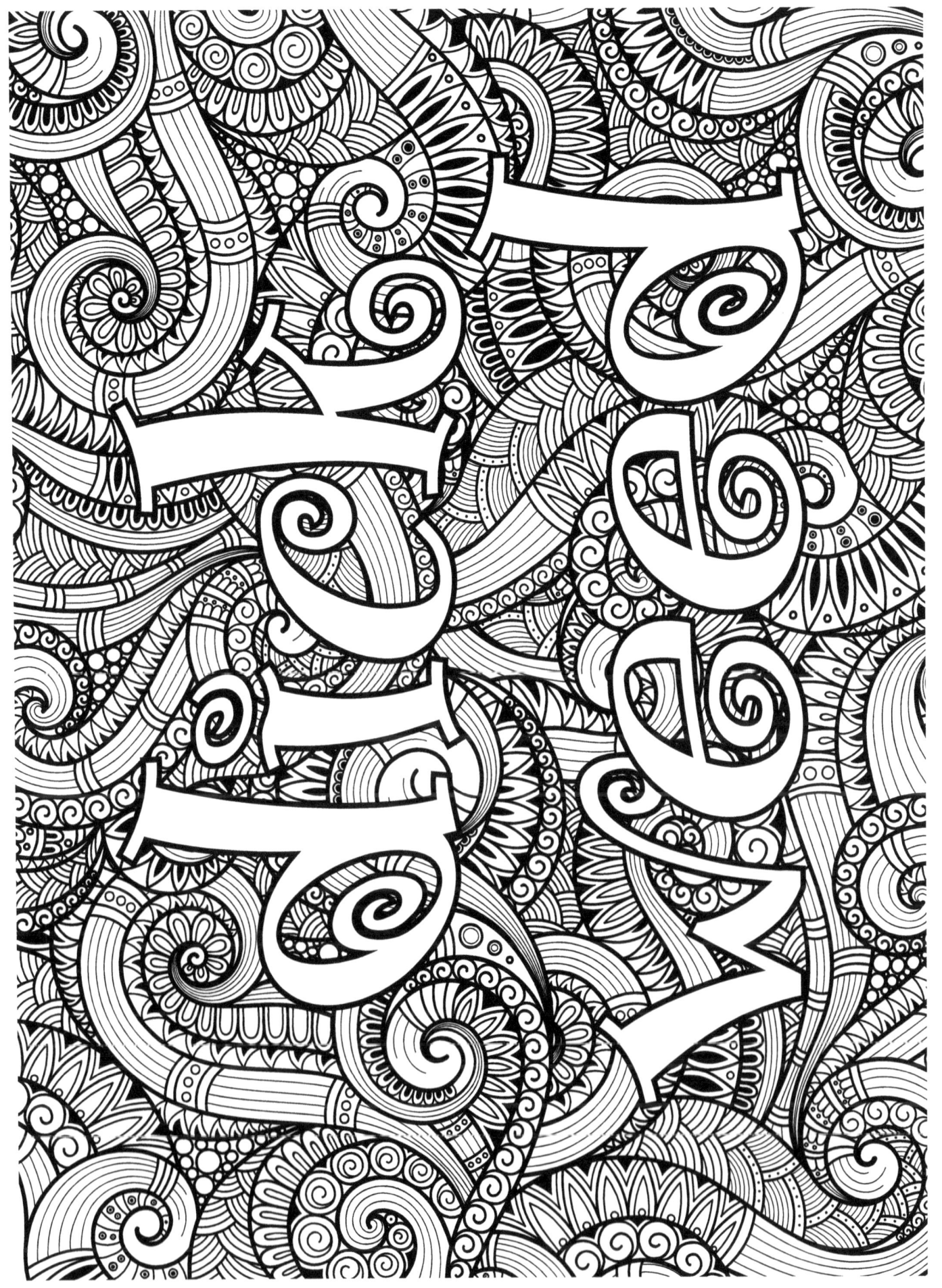

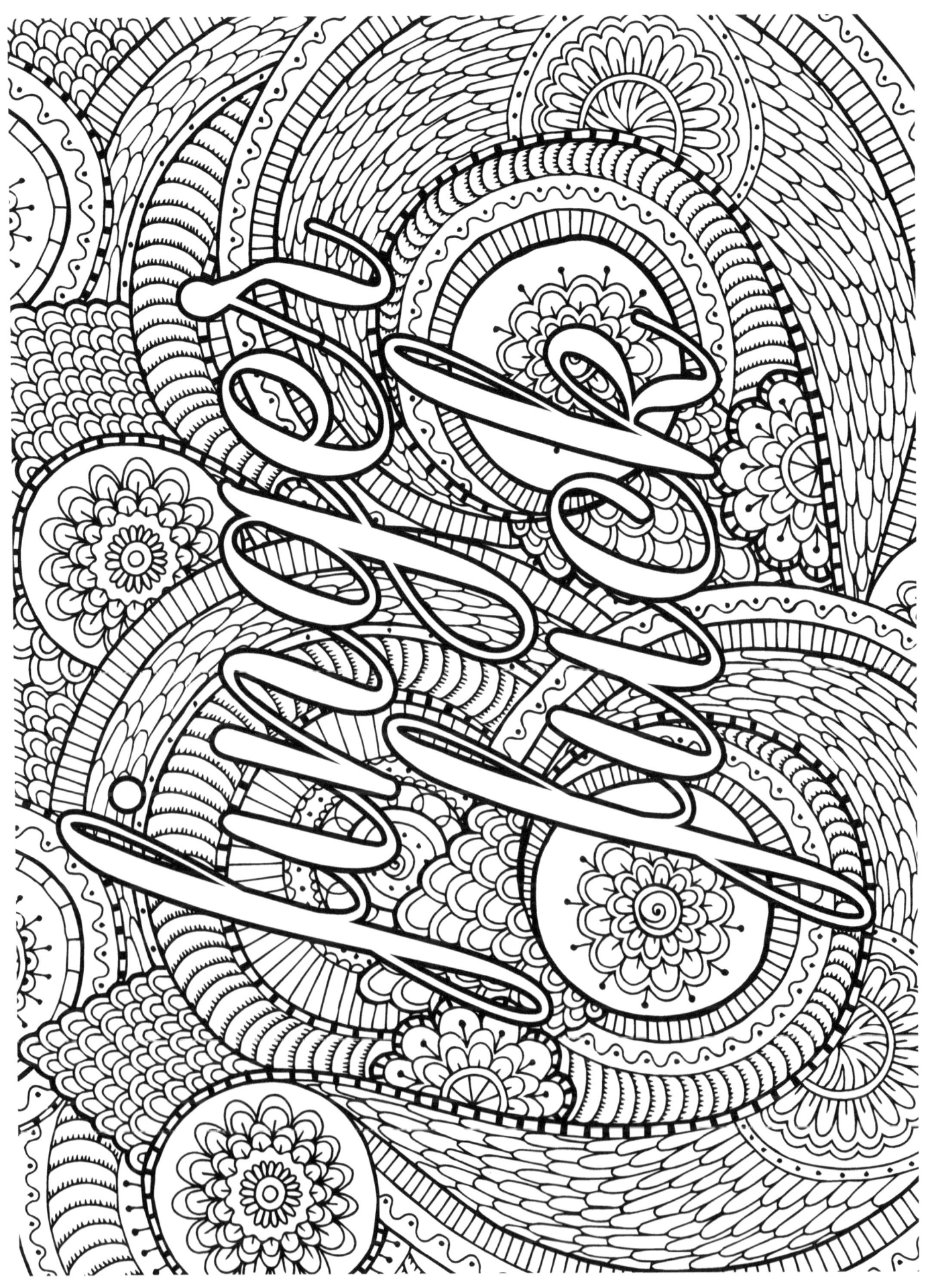

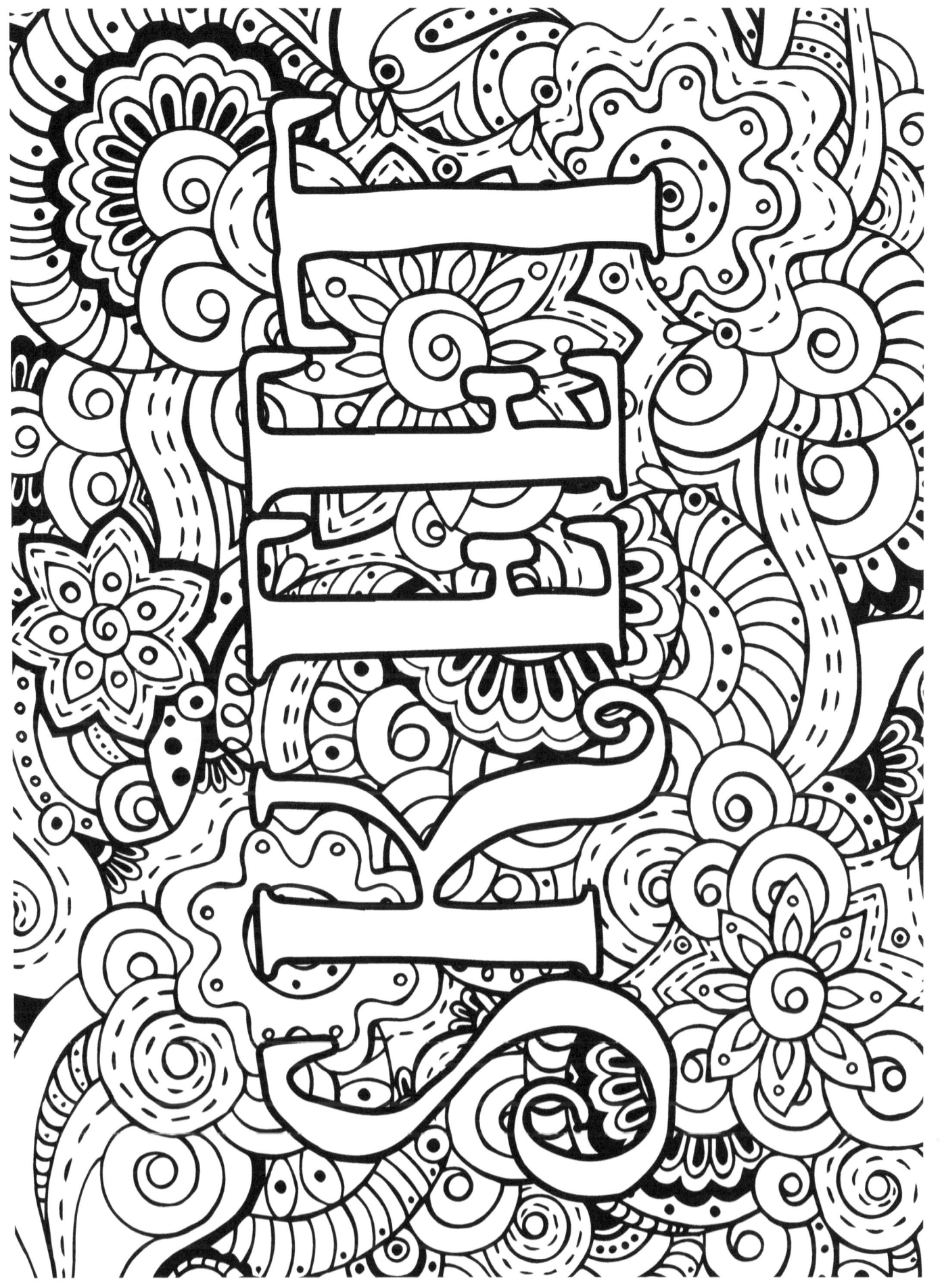

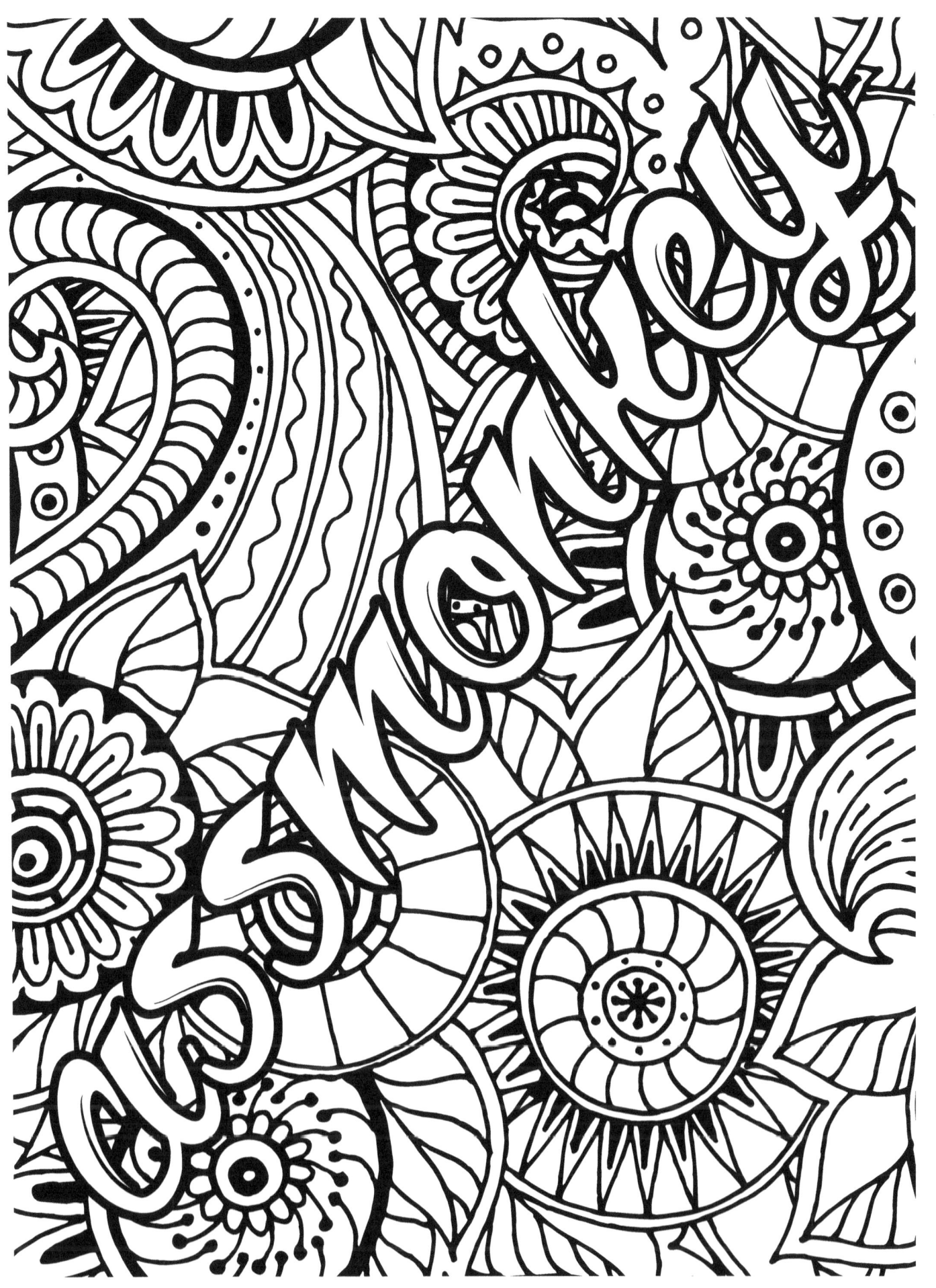

www.ingramcontent.com/pod-product-compliance
Lightning Source LLC
Chambersburg PA
CBHW060803020426
42264CB00021B/252